# In the Image of God

Art Projects
with Kids 8 Years Old
and Up

written and illustrated
by
Marge
Tuthill

Library of Congress
Catalog Card Number: 75-42050

ISBN: 0-8091-1926-9

Published by Paulist Press
Editorial Office: 1865 Broadway, N.Y.,
N.Y. 10023
Business Office: 400 Sette Drive,
Paramus, N.J. 07652

Printed and bound in the
United States of America

dedicated
to
The Tuthill Children
Larry, Resa
Nora, Bridget, Megan
and
all the children who
taught me while I was
"teaching" them.

I would like to acknowledge the as-
sistance and support of three people
who helped make this book possible.
They are Dr. Maria Harris and Sr.
Delia Lynch of Fordham University
and John J. Corazzini, assistant
chairman of the Riverhead School
District English Department.

# TABLE OF CONTENTS

# the Creed

Learnings that words might never convey can perhaps be promoted by offering those of any age, especially children, the time, space, place, way and stuff of life to discover God and His image within themselves. The way is the use of visual art in acts of re-creation. Re-creation expressed so clearly in the arts seems the essence of all life activities. Re-creation through art can give meaning to living.

1

I BELIEVE art activities can help us to use the stuff of creation with respect and originality, without waste, and help us to enhance that stuff with love, beauty and more meaning.

I BELIEVE art activities can help us to discover and to express love of God, self and others in both the doing and the result.

I BELIEVE art activities can help us to recognize the law and order inherent in the nature of things and help us to see that procedures often presented as laws are simply solid possibilities that should not limit.

I BELIEVE art activities can help us to feel good within and thus help us to rest and enjoy our inheritance of peace.

I BELIEVE art seems to provide the stuff and way for some of today's parables.

I BELIEVE art activities symbolize life tasks.

2

# the mission

The mission of teachers, leaders and facilitators in art activities is to provide opportunities for re-creation. Many so called art activities do not involve creativity. In order to successfully conduct creative activities, you must have the intent of providing the opportunity for others to create. Your part is not to guarantee a successful result for others. Your part is to provide an opportunity for others to experience re-creation. You can do your part in many ways. You can help mostly by providing the time, place, stuff and what is essential to the way. Leave plenty of space within the way for the freedom that is creativity.

Your attitude resulting from your intention will give you many ideas of how to go about setting up and conducting art activities. Included are some ideas that may be worth considering.

Starting any art work is often difficult for many individuals. Perhaps the

problem stems from feelings that there is a one way, a one right way to begin. Stress the idea that there are many beginnings as well as many routes.

Encourage participants to let their work be BIG, BOLD, and SIMPLE. This seems to lead to freedom and courage. It seems to relate to the total use of space and creates a fuller design in the space involved.

Discourage waste. Starting over is not as satisfying as figuring out how to right a mistake and doing so can actually improve the work. A good part of life deals with learning how to handle mistakes. Starting over in life is unreal. Learning how to go on is one of our greatest accomplishments.

Every work involving effort deserves praise. "Interesting" is a word to use to avoid being untruthful or uncharitable. When in doubt about what you see, ask

in an indirect manner. "Tell me about what you are making," seems like a good approach. Do not judge or guess. The wrong judgment or guess will hurt and something important may be missed.

Relating art to religious growth depends upon knowing the various individuals' starting points in both religion and art and moving toward discovery with the individuals. Understanding of God, others and ourselves comes to each of us in different ways, at different speeds, different depths. What counts is knowing, feeling and growing. Such understandings are apt to be lasting and affect ways of living.

A theme or process must be provided that relates to whatever concept or experience you hope to develop or touch. Your role is to arrange for the necessary time, space, stuff and any essential technical way as well as suggested ways.

You need to exercise care in presenting ways. If your way is followed exactly when unnecessary, creativity - re-creation will be lost along with most of the possible value of the activity. There always exists the very positive probability that members of the group will contribute ideas that increase the possibilities of the activity. A spirit of openness must exist.

**Stuff:** 1. Bigger-than-egg rocks or stones with smooth surfaces. 2. Water and something in the soap family. 3. Felt tip markers. Paint or crayons are possible substitutes. 4. Krylon or other protective coating.

**Way:** 1. Clean the rocks. 2. Using markers, place design on the rocks. Express the need to be careful of smudging. Even markers seem to need drying or setting time. 3. Wait a few hours and apply the protective coating. Krylon is a clear, quick-drying spray that protects and polishes.

**Hints:** Both the rock cleaning and the protective coating steps can be done for the group or by a few without taking away from the individual's creativity. Young children should not be asked to apply Krylon. Uses: paper weights, door stops or just looking. Rocks are rooted in the Bible and in nature.

# FINISH UPS

**Stuff:** 1. A selection of magazine pictures, either black and white or color. There should be many more pictures than the number of people in the group. Each picture should be cut in a way so that only part of the object, action or idea remains. Any shape will do. 2. Ball point pens, felt tip markers, pencils or anything black for black and white pictures. Crayon, colored pencils, colored pens or paint for the pictures in color. The medium depends upon the kind of detail in the picture. 3. White paper that is much bigger than the magazine picture (probably 9"x12" or 12"x18").

4. Paste or glue.

Way: 1. Each person selects the picture he or she would like to finish. 2. The magazine picture is placed and pasted on the paper so the picture can be completed. Care needs to be taken in deciding exactly where to place the picture. 3. Complete the picture with a suitable medium.

Hint: This activity serves to indicate there are many ways to finish things. The activity provides a use for old calendar, magazine and book illustrations that are ready for discarding. It probably will not be possible to duplicate the style and detail of the magazine picture in an exact manner. This difficulty provides a contrast that can be delightful. Those working on this activity should be aware of this so the duplicating does not cause discouragement.

11

# self-portraits

## and
## beyond

**Stuff:** 1. Paper of any size that is suitable for the work space available. 2. Crayons, colored pens or pencils, or any other appropriate medium that works with the paper size and can be handled with ease.

**Way:** 1. Discussion and demonstration seem good starting points. It does not matter how well you draw when demonstrating. If you do not draw well, it is good in that it does not put a burden on others to equal you. Through the process of discussion-demonstration, observations of the uniqueness of individuals and knowledge of self develop. Suggestions for a discussion-demonstrating approach begin with discussing all the various shaped heads (round, long, oval and all that you see). Begin to think of what can be seen. Usually, parts of the head are hidden by hair. There are many different hair styles and these hair styles all have

a shape of their own. Consider hair colors. Through discussion, see that not all the eye ball shows and reach the point of observing that eyes are white with a colored circular shape in the middle and a seemingly black pupil in its center. Many youngsters do not know the color of their eyes so it is sometimes valuable to take the time for youngsters to tell each other. Noses are hard to define and draw. The fewer the lines, the better. Mouths give expression. The upturned curve brings a smile; the downturned curve, a sad look and there is all the in between. Deciding about the curve of your own mouth is quite enlightening. Consider what part of the ear shows. Talk about necks and how long and thick or thin they are compared with the head and the body, shoulder to shoulder. Talk about skin colors. No one is really black or white. Handy black and white objects will help show this if compared with skin. Probably the color used would be a mix-

ture of orange, pink or brown with white
or black to make the best value. Con-
sider the shape and color of clothing
showing in a bust. 2. Provide the
time and materials for doing the self-
portraits.

# Hints: "Here I am, Lord!" and "God
called me by name" are themes
for self-portraits. A variation of
this activity can be using strips of
colored paper and paste emphasizing
feeling. These are apt to be partly
3-D. The discussion-demonstrating
process can be used for drawing
figures, trees, houses, or anything.

# starters
# and
# composites

# Stuff: 
1. Any choice of medium, including pencils, crayons, markers or chalk. 2. Paper or surface, including blackboard, to work on. This surface can be any size for the individual. It should be from 18"x 24" to any mural size for a group.

# Way:
1. Place a mark, line, shape, number, letter or scribble on the paper for the doer(s). If it is a starter for an individual, ask the individual to complete the work as a design or picture using the given starting point. A large group or divided smaller groups can be asked to work together taking turns adding lines, shapes and colors to the one work.

# Hints:
Life is built from starting points but leaves plenty of freedom. Composites mean sharing, togetherness and touch of community.

17

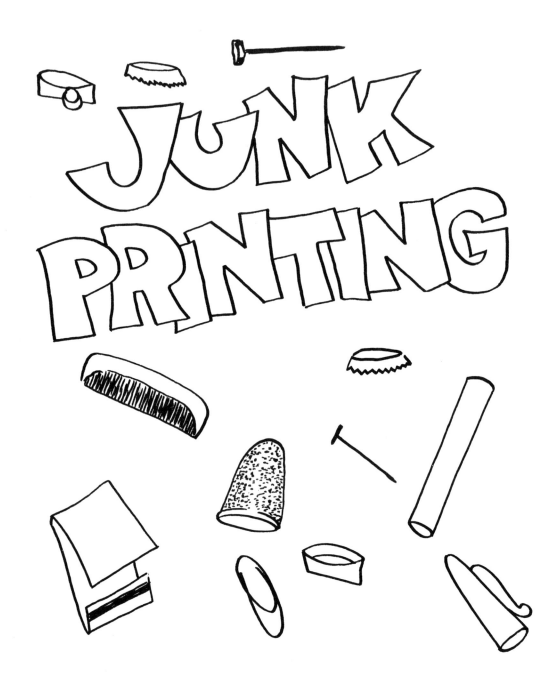

Stuff: 1. A number of flat, smooth, water-proof surfaces about 9"x12" for paint. Foil pie tins or old dinner dishes could serve as substitutes. 2. Poster paint or water base ink. 3. Paper that is neither smooth nor glossy in various colors and at least bigger than post card size. Construction paper is suitable. 4. Junk such as keys, paper clips, cardboard rollers, combs, bottle caps, pens, rings, string, and on endlessly. 5. A smooth surface roller or something flat to spread out the paint. 6. A sink or bucket of water. 7. Towels or rags for drying and cleaning.

Way: 1. Set up as many stations as needed. There should be at least one station for each color and a station for every four to six people. 2. Materials at each station should include a variety of kinds of junk and one color paint on the waterproof surface. 3. There should be a

special place designated for paper to be used and a larger area for placing prints to dry. This would probably be a portion of the floor and should be available for this purpose for twenty-four hours or more.
4. Place the paint on the waterproof surface. The paint should be spread out with a roller or something flat. If the paint is spread too thinly, it will dry too quickly. If too much paint is used, it will be too thick for printing and spread over surface edges causing a mess. Be prepared to add paint as needed during the activity. 5. The junk object is dipped in the paint and impressions are made by placing the junk object on the paper and applying pressure without moving the paper or junk object. The process is repeated in order to create the desired design or picture. Those printing should feel free to move from station to station as long as crowding is avoided. Junk

should not be moved from color to color unless first washed. 6. A quick demonstration is a suitable beginning.

# Hints: This seems to be a stand-up activity. Chairs just get in the way. The results of junk printing make colorful folder covers, wrapping paper and room decorations. The junk can be used to create religious symbols forming repeat designs or more complicated designs and pictures. Junk printing works well on fabrics with textile paints. Banners, stoles and various altar decorations can result.

# ILLUSTRATION

**Stuff:** 1. Drawing paper about 9"x12" or 12"x18". 2. Crayon, paint and brushes or substitute.

**Way:** 1. Each individual should have a knowledge of the subject matter used for illustrations. This subject matter might stem from participating in a field trip or a liturgical experience. It might stem from reading or listening to a story. 2. Each individual attempts to express in a visual way something important about the subject matter. With younger children, it seems good to simply ask them to illustrate something they remembered and liked very much. Let them know they

do not have to do this in a realistic way. It seems best to ask that the illustration be done without writing or labeling. This helps them to learn to communicate in a more fully visual way. 3. If possible, ask each person to share the illustration and talk about it to the group. When a youngster seems shy about sharing his or her work, it seems wise to find some positive comments to make about the work. This can help the child gain self-confidence.

# Hints: This activity affords individuals an opportunity to reflect and share their experience and knowledge. You find out what is important to the individual and thus know him or her a little better. This activity can be a very simple beginning of meditation.

# Stained Glass Windows

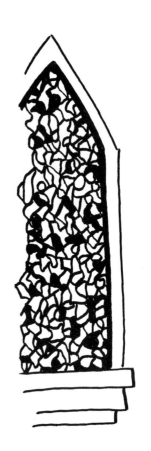

# Stuff:
1. White drawing paper about 12" x 18". 2. Crayons. 3. Black paint and brush, black marker or black crayon. 4. Scissors. 5. Compasses or circular shapes such as plates having about a twelve inch diameter. 6. Oval shapes of a similar size.

# Way:
1. Decide on a window shape. 2. Make the outside edge of the drawing paper correspond to the desired window shape. The rectangular shape of the paper is a good shape. An arched top outline may be formed by folding the rectangular paper in half the long way and cutting a curve from the top edge of the center fold to the folded side edges. The unfolded paper will have an arched top. A circle may be formed with a compass or by tracing a circular-shaped object and an oval may be formed by tracing an oval shape. These should be cut out with a scissors.

3. Design the desired shapes and objects of the window on the paper with thin black lines using black paint, marker or crayon. The eraser of a pencil can be used for the initial drawing. The eraser lines can be brushed away when no longer needed. Each shape and object must be recognizable without adding details that cannot be connected to the outside edge of the shape or object. Add the details that can connect with black lines. Break up the background with shapes formed by more black lines. Continue until every line connects with some other line and eventually with the outside edge of the paper. The lines can be tested by traveling with your finger from one line to all the other lines and the outside edges. The black lines are symbols for the lead that holds together all the stained glass. These black lines seem to make the stained glass effect more

authentic. None of the shapes resulting from the black lines should be very small or very large. 4. Choose colors for the objects, shapes and background. If two objects of the same color connect with each other, both will be difficult to recognize. It seems best to plan out the color combinations to avoid this problem. 5. Color with crayons. Do not use black. Bear down on the crayon to obtain a full color and a shining look.

# Hints: Stained glass windows work well for celebrations, holidays and inspirational themes. The style seems to call for rather formal and serious themes. Santa Claus and the Easter bunny seem more suited for other projects. Suggest the theme be one the individual considers very beautiful and important. If you wind up with some

Santas and bunnies, let it be. Stained glass windows may be made in other more complicated ways. A skeleton of the leaded areas may be cut from black paper with a scissors or knife. The glass sections can be filled by pasting colored tissue paper or cellophane to the back of the black paper edges around each shape. These can be displayed in windows so the light can shine through.

Stuff: 1. An assortment of discarded boxes. These can be selected for or by the group. A combined effort is apt to be desirable. 2. Scissors and X-acto or utility knives. 3. A variety of materials for covering the boxes including: poster paint and paper such as construction, shelving, tissue, wrapping, contact and wallpaper. 4. Securing materials such as glue, masking tape, scotch tape, string and stapler. 5. A variety of junk for details and finishing touches such as: buttons, cardboard

rollers, cloth, bottle caps, yarn and wire.
6. Wallpaper paste and water for papier-
mâché is an option.

Way: 1. Present the idea that a
whole new world can be created with
boxes. A box or combination of boxes
can be converted into animals, people,
plants, buildings or just about anything.
2. Begin with a planning session making
rough sketches of what is to be made
and deciding how to go about it. This
is a good working together project;
however, it seems best to give the op-
tion of working alone or as part of a
small group without stipulating the group
size. If a very large object is planned, a
group seems to work best. 3. Allow work-
ing time. The project will probably require
several sessions. The number of sessions
available for the project will determine the
complexity. One of the simplest ways of

working is to wrap the box in the paper suited for the box's new role and then to secure additional wrapped boxes or parts with string, paste, tape or whatever is needed. Just one wrapped box with added details can quickly become an original animal or object. More complicated ways would involve the use of many materials. The shapes of boxes can be changed by cutting away parts of the boxes with knives and/or bending and molding sections covered with several layers of papier-mâché. There is no one way to do this project. There are many ways and many results. This is a risky activity. You assist most by helping to solve the individual problems that evolve.

# Hints: This seems a good project for covering a long term unit or variety of units. Unit subjects could include appreciation of creation, Bible study or new

views of life. This is one of those projects that people are apt to want to finish at home. This seems fine with adults, but presents a problem with children. If the attitude of understanding of the child's need for creative expression is lacking, working at home results in a finished project created by adults. Very often, this is because the child coaxes the parent into helping. The child is cheated of the joy of creating and the feeling of success. It is the kind of joy and feeling that a child cannot project or expect. It simply comes and builds self-respect and confidence.

# HONEST COPYING

# Stuff:

1. A varied collection of reproductions of famous paintings about 18"x24" if possible. The reproductions should be large enough to be easily seen by the group. The more styles, the better. There can be anywhere from about four to ten reproductions depending upon the available display space. 2. Drawing paper about the 12"x18 size.
3. Crayons or substitute.

# Way:

1. Display the reproductions so they may be seen by everyone. 2. Explain that the reproductions are the work of famous artists. Share interesting information about each style, artist or painting. 3. Everyone should choose one reproduction to try to copy. Stress that no one should expect to duplicate the work exactly, but the trying can be fun and much can be learned by studying an artist's work in this way. 4. Start work.

5. When they finish, ask them to sign the work by naming the artist and the title of the painting. Ask them to add "copied by" and sign their own name. Be sure to explain that the style, idea, design, colors, etc. were worked out by the original artist so the painting still belongs to that artist even when copied. Copying an artist's work can be compared with copying the words of a poem or song. The one who first wrote the poem or song is the creator and gets the credit. When you copy, you do not create.

# Hints: This is a good art appreciation activity. Finding reproductions is not difficult if you make your need known. Paintings with religious subject matter can be used. This activity triggers discussion and thinking about the meaning of honesty.

Stuff: 1. Background material such as felt, burlap or other sturdy cloth. The edges of the background need to be finished by sewing or fringing. Usually there should be an open loop along the top edge through which a dowel or rod can be placed. The background does not have to be a solid color, however; any design

should be subtle. The size of the banner depends upon the use. 12"x18" would seem to be about the smallest and the banner would have to be quite simple. Very long slim banners are sometimes effective. 24"x36" seems an all-round good size. If the banner is to be used on a banner standard, check the size of the standard. 2. Scraps of felt and other cuttable cloth. This means the edges should not fray when they are cut. 3. Elmer's glue. 4. Newsprint, kraft wrapping paper or some other paper the size of the banner for making a layout.

Way: 1. Make an exact layout of the banner on paper. Simple banners seem to be the most effective. The banner should convey a message in a clear but deep way. Banners do not have to include lettering. Some are more

effective without lettering. All the parts and details of the banner need to be large enough to cut out. 2. Determine the color combinations. 3. Cut out the objects, shapes and lettering. 4. Trace them on the material to be used for that specific part. 5. Cut out all the cloth parts. 6. Arrange all the cutouts on the background material. 7. Secure with Elmer's glue. 8. Remove any excess glue with a damp cloth. 9. Allow time for the glue to set.

# Hints: Banners may also be made with paper. Cardboard or paper backgrounds may be used. Some window shades also work well. Many kinds of paper can be used for the objects, shapes and details including metallic, construction and contact. Large, colorful, plastic disposal bags work well with contact paper. Banners can be made by individuals or groups. They provide a satisfying way of participating in liturgy.

# String and Yarn

Stuff: 1. Yarn or string of various colors.
2. Colored cardboard or cardboard covered with paper suitable for a background. The cardboard should be bigger than a cigar box top. 3. Elmer's glue or a substitute in a similar squeeze bottle container. 4. Scissors.

Way: 1. Prepare the cardboard as a background if necessary. Usually the background would be a solid color but there are other possibilities. If there is detail or too much going on in the background, the final results may be confusing. 2. Using glue instead of a pencil, begin the initial drawing on the background. Using the glue container as the drawing tool makes a more free-flowing design and eliminates the possibility of pencil lines too detailed for the glue and the yarn or string. Try to control the flow of glue so the glue lines are thin. Draw just one shape or a few lines. 3. Before the glue dries, place the yarn or string on the glue lines. The individual working will do the best job of judging if it is better to cut the yarn or string before or after gluing. 4. Continue

glue drawing and adding yarn or string bit by bit until finished. 5. It is possible to fill in sections with glue and add the yarn or string in order to make the work more colorful and create patterns. The finished work should not be stacked until the glue has time to set.

# Hints: It seems best to concentrate on the inner areas of the background and not to do too much near the edges. The results of this activity have refreshing simplicity. Drawing with glue helps open individuals to the idea of change and new ways. Christ wrote of new ways in the sand.

Toothpick Triangles

Stuff: 1. Boxes of toothpicks. A box for every three or four people seems ample. 2. Elmer's glue. 3. A flat working surface such as the back of a paper tablet. This can be used for holding all the parts of the work between sessions. 4. Thread.

Way: 1. Form triangles with the toothpicks by gluing the tips of three toothpicks together. This seems very difficult at first; however, people do seem to find their own way to solve this problem if they keep trying. Continue until about twenty-five triangles are made. 2. Allow time for the glue to set. You will probably need an area for storing that will be undisturbed until the next session. 3. When the triangles have had time to set, begin making pyramids out of sets of three triangles. As the glue sets, begin combining the pyramids. Pryamids are joined together in a variety of ways creating unusual inner and outer shapes. If more triangles are needed, they should be made early in the session to allow time for the glue to set. Continue building until satis-

fied. 4. Attach a thread to an appropriate part of the structure if the structure is to be hung as a mobile. The structure also works well as a stabile.

# Hints: This would be a very difficult project below the fifth grade level. Many more things can be done with the structures. They can be painted bright colors. Tissue paper can be added to fill in some triangles. This is a good time to consider the value of patience and the patience of Job. There is a trinity of threes continually forming a unity of oneness in this activity. This displays the simplest and beginning concept for understanding the Trinity. That mystery extends far beyond this type of visual expression.

# LETTERING

Stuff: 1. Pencils. 2. Scissors 3. Pre-cut paper blocks having the height of all the letters and the width of the average letters. Two by three inch blocks are a good average size. 4. Oak tag strips with the following dimensions: longer than the cut paper blocks; a width the same or less than one-third the width of the cut paper blocks; a height the same or less than one-fifth the height of the cut paper blocks. A one-half inch wide strip works well with the two by three inch blocks. 5. Paste or glue. 6. Background paper about 12"x18" or 18"x24". 7. Ruler.

Way: 1. A demonstration seems advisable. The basic strokes in forming letters are lines and half circles. The tag strip is used to form the strokes of the letters on the paper blocks. Half circles are treated as rectangular shapes initially. Later the corners are rounded on both the outside and inside edge to provide the necessary curves while preserving the uniform thickness. Whenever possible, the outside edge of the block should be used as the outside edge of the letter. The strip should be placed on the edge of the block with care and the inside edge of the strip traced lightly with pencil. Strokes completely inside the block should be made by placing the strip on the appropriate spot and by tracing both edges of the strip. All pencil lines should be very light so they can be removed. All the letters can be made with the one size block except the "M" which

46

requires a slightly wider block. The "W" can be made by placing two "V's" together. The Gothic letter "I" does not have serifs and is made by simply tracing the strip vertically. 2. Cut out all the letters with care to preserve the uniform thickness. Cutting right into letters with inside openings makes careful cutting of the inner spaces easier. The cut will not show later. 3. Erase any lines that show. 4. Place a guide line or as many as necessary on the background paper to make it possible to place the lettering in a uniform way. The guide line will be straight if measured with a ruler on both sides of the paper. 5. Arrange the letters. Lettering should not touch or crowd the background edges, other letters or any other objects. There should be a space as big as a letter between words. The space between letters in a word is less

47

than half that amount of space. These spaces cannot be measured because each letter has a different outside shape and the open spaces between letters have many varied shapes. The letters should be placed so the space looks the same as the other spaces between letters in the word. In order to center a word on a guide line, find the center and place the middle letter first. Add the letters belonging on both sides. 6. Lightly mark the edge of where each letter begins on the background paper. 7. Remove the letters one at a time and paste or glue the back surface. Replace the letter to where it belongs on the guide line and apply some pressure.

## Hints: The lettering described is a simple Gothic style and rather easy once understood. It probably should not be attempted below the sixth grade age level. Since there is

quite a bit involved in doing this lettering and there are so many things to remember, it seems best to spend the working period advising individuals. Letters in a word should be one color and should contrast with the background. It seems good and helpful to know how to make clear and bold lettering. Searching Scripture for sayings to letter seems good. Words and phrases can also be done to express the wonder of God.

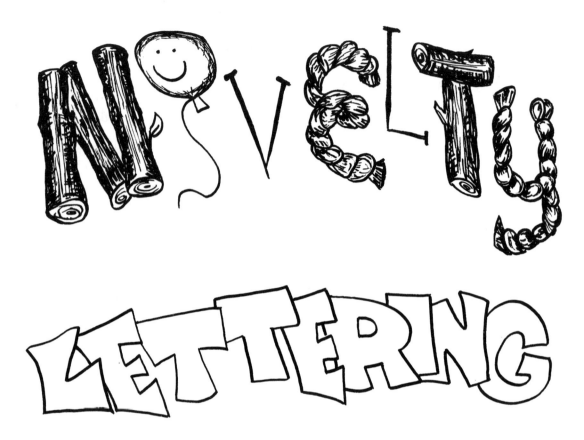

# NOVELTY LETTERING

**Stuff:** 1. Paper about the 12"x18" size. 2. Pencils. 3. Erasers. 4. Crayons, colored pencils or colored markers.

**Way:** 1. Discuss novelty lettering using samples. Novelty lettering can be found in all the places you find advertisements and trade names.

It is good to have samples to display
briefly. If samples are displayed be-
yond the discussion period, the temp-
tation to copy may overcome original-
ity. The lettering does not have to be uni-
form in size and thickness but it should
look as if it belongs together when fin-
ished. Novelty lettering can be free and
casual looking. 2. A good beginning is
to sketch very lightly with pencil or
eraser the single stroke letters of
the word or words to be used. This
can be done in printing or long hand
and should not be crowded. 3. The
lettering can be made thicker by add-
ing outlines around both sides of
all the strokes. Doing this on both
sides of the strokes helps to keep
the basic shape of the lettering. Many
forms of novelty lettering can develop.
Letters in a word can be joined together.
Letters can be decorated to look like

cloth or to have other textures. Adding details and edge work can make the letters look as if they were made of logs, ropes or whatever you might think would work. All the rounded shapes in the letters can be made into smiles, balls, apples, etc. Some ideas would work best with single stroke letters. An example would be making all the strokes look like straight and bent nails. Sometimes, just one letter can be decorated and made to also signify some object or idea. There are no limits to ideas once you begin. Just making thick attractive casual lettering is satisfying.
4. When the drawing is done, erase unnecessary pencil lines. 5. Add color and details.

Hints: Working with slogans, phrases or words relating to topics the group is studying makes it possible to relate this activity to almost anything. This

is an informal, fun way to be visually creative in expressing words. Novelty lettering speaks through words and design. It seems a great way to spread the Good News.

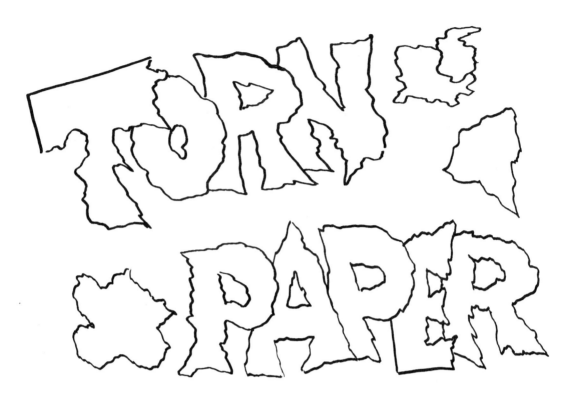

Stuff: 1. A variety of colored paper for tearing. Scraps from other activities are good. 2. Construction paper of various colors for the background. Any size from 8"x10" to 12"x18" seems suitable. 3. Paste or glue.

**Way:** 1. The fingers become the scissors. Limit your doing to tearing the objects and details of your picture or design. You are drawing by tearing and cutting by tearing. Keep your hands close to the tear you are making for control. The tearing creates unusual, original edges for things usually drawn rather stiffly. 2. Arrange the objects and details on a background of a different color. Be sure each part fits and each color stands out. 3. Paste everything where it belongs.

**Hints:** Using your hands to do a job customarily done with pencil and scissors is a way of learning how to do without things that seem essential. The joy of poverty is expressed.

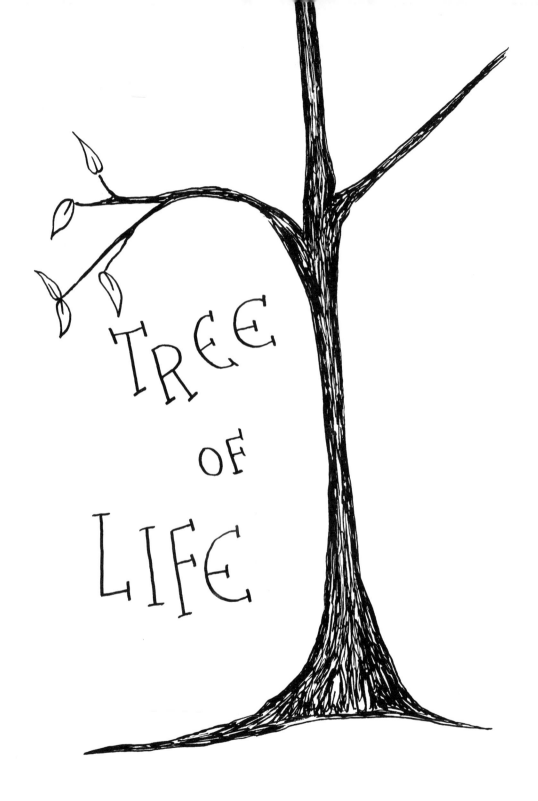

TREE OF LIFE

Stuff: 1. Obtain as many branches as needed. Choose branches that have a fullness and balance to cause them to resemble trees. The size is optional and should be determined according to the situation and purpose. An entire group can work with one branch or there can be a branch for each individual or small group within the group. 2. White paint and brush if you choose to have a white branch. 3. Materials to make the decorations for the tree. These could include: scrap paper, tooth-picks, ribbon, all kinds of attractive junk and blown out eggs. (Eggs can be blown out by making pin holes in the opposite ends of the egg. With mouth or a straw placed on one end of the egg, blow the insides of the egg out the other pin hole into a container such as a bowl. Blowing can be made easier by making the pin holes larger. Patience is required. It is like blowing up a balloon. At first it seems as if it cannot be done but it becomes easier once started.

The empty egg shell should be cleaned by running water through the pin holes. The egg should be allowed to dry before decorating.) 4. Paint, crayon and markers would probably be helpful in transforming the materials. 5. Scissors. 6. Elmer's glue. 7. Paper clips, string or thread to attach items to the tree. 8. A base to hold the tree upright. This could be a bottle, a container filled with plasticine, stryofoam, or a wood block with a hole drilled into it. 9. Cold water dye for egg shells.

Way: 1. Secure and display the tree. 2. There should be a discussion time to plan the meaning of the tree and ways to express the meaning. A motif or motifs need to be determined. These could include: decorated blown out eggs; tissue paper flowers; two-dimensional shapes or words decorated on both sides; paper sculpture doves, stars, butterflies or snow flakes made with

simple folds. There is really no one way to make such things. Explaining ways will take away from discovery and creativeness. The planning period will allow a chance to make decisions including what materials are needed for the work period. 2. Prepare for and provide a work period. 3. Attach the items to the tree with the paper clips, string or thread.

# Hints: The tree can signify numerous events, occasions and ideas. The tree of life is one of the oldest symbols for eternal life and can relate to most religious themes.

# TELLING ABOUT

**Stuff:** 1. White or light colored drawing paper about the 9"x12" or 12"x18" size. 2. Crayons or substitute.

**Way:** 1. Participants should be asked to show in a visual way something good and positive about themselves. Ask them to express their good feelings about themselves, something they like about themselves, something important about themselves.

There should be no limit to the way an individual does this beyond expressing something positive that makes the individual feel happy about himself or herself. 2. Allow time to think it over and work. If some have difficulty starting, you might suggest that there are many ways this can be done just as there are many ideas each individual can choose. Stress the point that the ways to do this can come only from inside the person. If some seem troubled, you might suggest that they work on what they like to be or feel. A clue for this might be recalling daydreams.

# Hints: It is good to look at the positive side of oneself. We should encourage youngsters to do this. Building self-image makes loving others as oneself far more beautiful. There is good in each of us for we were made in the image of God.

CONTAINERS

62

**Stuff:** 1. Jars, bottles, cans and cigar boxes. 2. Half-inch strips of paper toweling cut with a paper cutter or scissors. 3. Wallpaper paste mixed with water to a soupy consistency. 4. Bowls for the soupy mixture. There should be a bowl for every three or four people working. 5. Plastic coating spray, varnish or shellac. These should be clear. All three can be obtained in spray containers. If you do not use the sprays, you will need brushes and solvent for cleaning the brushes. 6. Colored tissue paper and/or magazine pictures that are colorful. 7. Newspaper to protect the working area. 8. A nearby sink or pail of water and towels for cleaning hands. 9. Scissors to cut the tissue paper and magazine pages.

**Way:** 1. Select a container. 2. Cover the desired area of the container with papier-mâché. The papier-mâché is made

by soaking the strips of paper toweling in the soupy mixture of wallpaper paste and water. The strips are usually easy to apply. They can be torn and shaped to create the effect you want. It seems wise to cover all areas having printed surfaces; however it may be interesting to leave some areas as they are. This would depend upon the attractiveness of the original surface. Apply several layers of papier-mâché. 3. Cover the papier-mâché with selected tissue paper and/or magazine pictures that have been dipped in the papier-mâché mixture. 4. When all is smoothed out and arranged to satisfaction, allow time for drying. This may take a week or even longer. 5. When dry, spray with a protective plastic coating, varnish or shellac; or apply varnish or shellac with a brush. If you want a waterproof surface, do not use shellac. The plastic coating will dry very quickly. The others usually take at least

a day. 6. Allow for the final drying period.

# Hints: The containers can become vases, pen or pencil holders, cookie jars and fill many other kinds of uses. There are many other ways to re-do containers including painting, using contact and other sticky backed paper, and wrapping with string held by glue. Bottles can be made more interesting by cutting them with a bottle cutter. This requires supervision when youngsters are involved: Creating does involve making things that can be used. All that God created for us has a purpose as well as beauty.

Stuff: 1. Long strips of drawing paper. The strips can be made by cutting 12"x18" paper in half the long way. 2. Pencil or ball point pen.

Way: 1. Fold the paper in half and fold it in half again so that when unfolded there are four boxes across the long way. 2. Each individual should choose a funny happening, joke or story and tell it step by step, box by box. Sketch the scene and characters in the first box. The characters can be people, animals or even objects. 3. Add the necessary words to the box and draw a cloud around the words. This

should end with a pointed shape toward the character responsible for the words. These cloud shapes are sometimes called balloons. 4. Continue with the other boxes. If more boxes are needed, just add more strips of paper with tape on the back. Continue until finished.

## Hints: Humor has a part in our lives and is a very real part of being a Christian. Cartoon strips are also good for explaining things. A cartoon made from a single box on larger paper can be done, but it is more difficult to express something in just one box.

**Stuff:** 1. White drawing paper about the size of index cards. There should be about five to ten sheets for each member of the group. 2. Crayons, colored pencils, pens, markers and possibly brushes and paint.

**Way:** 1. The task is to create doodles on the white paper using combinations of the available mediums that appeal. The goal is to create doodles that have no subject matter or symbolic shapes. The results should be non-objective. This serves to free those concerned about their art ability and serves to encourage creativity. 2. Each person should be encouraged to do a number of these and to try to make each one very different from the others.

**Hint:** This can also be done as a collage. There is a freedom and openness in trying to create beyond what we know.

**Stuff:** 1. Construction paper about 9"x12" including a variety of colors but no black or white. 2. Manila paper or any opaque paper that is easy to cut and the same size or just a little smaller than the construction paper to be used. 3. Masking tape 4. Window space ample enough to display the entire group's work. 5. Scissors. 6. Pencils, crayons or markers.

**Way:** 1. Sketch on the manila or substitute paper silhouettes of the object or objects desired. Stress the idea that the outline will be the only way available to identify the object. If inner areas are included, they must be open spaces that can be cut out and they must be big enough to cut out. There is a tendency to sketch small details when using a pencil. This can be avoided by cautions or by substituting for the pencil a crayon or

a marker. 2. Cut out the object with care. Inner sections are easier to cut out if a cut is made from the outside edge into the inner section involved. The cut can be taped back together and will not be noticeable 3. The cut out silhouettes are placed on the colored construction paper with masking tape. Remember, this background paper should not be black or white. A bright color would be best. The taping is done by making a roll from a small piece of tape with the sticky side on the outside. Flatten the roll and place it on the back of the object in such a way that it does not stick out beyond the edges. Use as many rolls as needed. Place the object on the background paper and apply some pressure with your hands. 4. Tape the results on a window so that the objects are facing the outdoors. 5. After a few sunny days or a week, remove them from the window. 6. Carefully remove the silhouettes

from the background. The silhouette covered area will be the original bright color of the background paper and the rest will be faded to a light value of the original color.

# Hints: The power of the sun can reflect the greatness of God just as thoughts of the light, warmth and nourishment from the sun reflect the goodness of God, the creator of the sun. Perhaps this is a good time to consider the reasons early men thought of the sun as a god. The fact that things fade is usually a problem and considered a bad thing. This activity puts the process of fading to a good use. There seems to be good and bad in most things. The use of the thing seems to be what counts.

74

**Stuff:** 1. Drawing paper about 9"x12" or 12"x18". 2. Crayons, colored pencils, markers or water colors.

**Way:** 1. Discuss the many traditional Christian signs and symbols as well as their meanings. Included might be: the alpha and omega sign for God; a dove for the Holy Spirit; the lamb, sun, fish and chi ro for Christ; the rose or lily for Mary, mother of God; a butterfly for the Resurrection; wheat and grapes for the Eucharist; a ship for the church; a mountain for the altar; an anchor for hope; a heart for love and charity and the cross for Christianity. There are many others. You may want to add more and your group may add some. Explain that signs and symbols develop as they have meaning for people and these join tradition for as long as they have meaning for many

people. Discuss the signs and symbols that individuals develop. For example, some find the sea to be the clearest and strongest symbol of God. They feel God is all the wonder of the sea and more. You may be able to add your own examples and the group may also add their examples. 2. Ask the group to attempt signs and symbols of their own or a traditional sign or symbol in their own way. If you have not displayed examples of signs and symbols, the results will be more creative. However, it probably would be best to show examples of the Greek lettering used in some signs. 3. Distribute materials and allow work time. 4. If there is time, some group members may be willing to discuss their symbols or signs.

**Hints:** A sign is simply a part of the actual material thing and involves a form of copying. A sign stands for the word or thing that it partially shows. A symbol stands for a meaning or idea about an object or concept. It is not a visual copy of what it symbolizes or stands for. This activity seems very much like a visual form of prayer.

**Stuff:** 1. Black or grey cardboard for the background. The backs of paper tablets or laundry inserts for shirts are fine. This cardboard can be cut in half if you wish to cut down the time needed to finish the project. 2. Squares of paper in a variety of colors and about one half inch in size. These can be prepared with a paper cutter. It is not necessary, but it is more effective if the squares have a thickness. This can be accomplished by pasting the colored paper to the tag board before cutting the squares. Old manila folders are a good source of tag board. Rubber cement applied to both surfaces thinly and allowed to become tacky before

joining the surfaces works very well. Metallic or glossy paper adds to the effect and so do colorful pages from magazines. These three types of paper are usually rather thin and will need the tag board backing. 3. Pencils. 4. Rubber cement or paste. 5. Scissors.

Way: 1. Very lightly with pencil sketch a simple object, design or scene. Make sure all the details and parts are big enough to eventually be formed by the one half inch mosaic squares. 2. Plan the color combination and even label the sections according to color. It will be confusing if two objects touching each other are the same color. 3. Select and begin placing the mosaic squares. Use rubber cement to secure the squares. Apply rubber cement to a small area of the background and place the squares when the rubber cement becomes tacky. The

advantage of using rubber cement is that the excess can be rubbed off once it dries. If rubber cement is not available, another paste can be substituted. (It seems best not to use rubber cement with children below the fourth grade level.) The squares should be placed so there is just a little uniform space between each so that the background shows. This spacing is important because it creates the mosaic effect. It may be necessary to cut some of the squares in order to follow the pencil outline. The objects or shapes of the design should be worked on first. The mosaic pieces should be placed on the interior sections first. Continue in such a way that the outside edges are done last. The irregular squares will not be as noticeable on the outside edges as they would be toward the center of the work. The outside

edges can be trimmed with a paper cutter for a finished look when the mosaic is completed.

# Hints: The mosaic art of Christianity is rich in history, religious symbols and design. This project affords an opportunity for appreciation of mosaics as well as the subject matter. The activity is a lesson in planning and putting the pieces together and the lesson seems a symbol of many life – activities.

All of these activities are beginnings. There are many varied ways of completing these activities and there are many new beginnings that these activities may suggest. These activities are meant to provide new beginnings. If you and those you work with hold open and searching views, together you will continually discover and create new beginnings that will in turn beget many more generations of activities.

# stuff about stuff

Knowing stuff about stuff does matter. There are advantages and limits to stuff of every kind and quality. There are always new kinds of stuff being marketed. Some are great but the basics seem to be old standbys that go back beyond our childhood.

If you have a budget, it should be used for good basic stuff. Even without a budget, it is possible to accumulate good basic stuff by making your needs known and searching for funds and materials. It is also possible to rely upon the group to bring and share materials. It should be remembered that this can become a stumbling block for some members of the group.

Before you start accumulating stuff, you need to consider if you have the storage space to accommodate the stuff. It is worth finding the space. Storage areas should be clean, dust free, dry and

without direct sunlight.

Basic stuff would include drawing paper, construction paper, paste, glue, scissors, paint, brushes, crayons, colored pencils, colored markers and tape. Attention needs to be given to the quality of stuff. In the name of economy, cheap paper, cheap scissors, cheap crayons and many other things have been obtained and rendered useless. Paper that will not hold mediums and cannot be cut without rough edges, crayons that will not color and scissors that will not cut can turn creative activities into experiences of frustration without much possibility for results.

In the name of economy, stuff is also purchased in bulk. This can be good but often is not. Gallons of glue, paste, paint or anything are much cheaper. However, if the jars are glass and break, more is lost. If the

container is not recapped properly, more is wasted. Large containers are not easy to handle and require more storage space. Some items such as liquid poster paint, paper and markers deteriorate if stored for too long a period.

Saving money on supplies can mean spending more time, space and effort. Saving money can also result in waste. Economy needs to be considered from many views.

There are many kinds of equipment available for art activities. A paper cutter is the one large basic piece of equipment that seems almost essential. An eighteen inch paper cutter can be obtained for a reasonable price. It will serve many purposes in preparing and carrying out activities.

Today, it seems possible to buy kits that do almost anything and

include everything. The biggest value of these kits seems to be the instruction booklet normally included. Even the booklet usually goes too far by going beyond what needs to be known in order to describe how to do the pre-created project. Many kits with prepared designs and drawings rob the activities of creativity. Good books and instruction sheets can be obtained more cheaply. After reviewing the information, you can obtain the quality and quanity of needed materials more effectively.

Lots of stuff can be obtained from local merchants, groups and individuals. The local printer always has scrap paper and some of it is excellent in quality with intriguing sizes and shapes. Wallpaper books and odd rolls are usually available from those who sell and work with the stuff. Lumber

yards and contractors discard a great deal of scrap lumber, paneling and delightful odds and ends. Merchants selling cigars and cigar smokers accumulate cigar boxes that are great for storage containers and activities. Knitters always have scraps of yarn. Every household discards numerous coffee cans and other containers. Stores discard many boxes and styrofoam packing materials.

Magazine and calendar pictures are great to accumulate. Storing magazines is difficult, but filing magazine and calendar pictures according to categories that help you does not take up much space.

The list of stuff that does not cost money is never ending and just requires open imagination. Much of this stuff is bulky and hard to store, but it can be obtained rather quickly when needed if sources are found and

alerted beforehand. The real cost is time and effort spent in organization.

It seems wise to see and test art materials before you buy or obtain them. When obtaining stuff, think over your situation, your funds, your time, your space and the needs of your group or groups. Act accordingly. The best decisions will spring from your thinking and evaluation of your own situation.

# basic stuff

DRAWING PAPER: An all purpose white draw-
ing paper such as a vellum in sixty pound
stock seems suitable for most finished
work. Test it first to be sure you can work
on it with different mediums and to be
sure that it can be cut with ease. It is al-
so good to have manila paper and news-
print for layout work and scrap.

COLORED CONSTRUCTION PAPER: Eighty pound stock in various colors seems suitable. The most frequently used colors are red, yellow, orange, blue, green, purple, pink, brown and black. It seems wise to have several different hues of the greens and blues. Be sure to see the colors before you order. Some packages of assorted paper are also helpful.

BROWN WRAPPING PAPER: This can be obtained in large rolls and is an inexpensive material for murals. It will serve many other purposes.

PAPER HINTS: It seems wise to see and test any kind of paper before obtaining a supply. Any reliable store or supply company will be glad to supply you with samples. Remember, you do not need the best. You need the stuff that will do the job. Try not to obtain over a year's supply. Most paper seems to begin to fade and deteriorate after

about a year. The standard sizes are usually 9"x12", 12"x18" and 18"x24". The largest of these is difficult to store. Be sure you have space for it.

SCISSORS: These should be nickel plated forged steel. The four or five inch sizes seem best. Blunt scissors are good for the grade one level and below as well as for anyone who might have special problems. The pointed scissors seem best for all others. Beware of inexpensive scissors. They usually do not cut sharp edges. This is frustrating, especially for a child who is apt to wind up feeling to blame for the failure. Inexpensive scissors also come apart quite easily.

SCISSOR RACK: This is an inexpensive item that holds from thirty to fifty scissors depending upon the style. A rack saves scissors from abuse and loss.

CRAYONS: There are many good brands. If in doubt, test the crayons. Eight color sets are usually suitable. The kindergarten size seems very good to use in the elementary grades. They last much longer. The slimmer crayons really do not have many advantages over this larger size. The problem usually seems to be the word kindergarten on the label. Flat pressed crayons are a novelty and fun to work with. Contrary to popular belief, crayons are rather difficult for young children to use effectively and can be handled more sucessfully by those who are older. The real advantage has always been that crayons make very little mess.

COLORED PENCILS: There are many good brands of colored pencils. These should also be tested if in doubt. The twelve color sets offer an ample

color selection. Pencils are suitable for small or detailed and textured work. Using them to fill in large areas is like scrubbing a floor with a tooth brush. Sargent puts out a Plasticolor Pencil Crayon that works well for youngsters. They are a nice cross between a crayon and a pencil. They seem very durable.

POSTER PAINT: Black, white, red, blue, and yellow are the essential colors. Everything else can be made by mixing these colors. Liquid poster paints should be ordered in pints or quarts. They do not always store well over long periods of time and if not recapped properly, the paint dries up. Powder paint lasts longer. You mix the powder with water as you need it. It can be stored longer in less space. The longest lasting and easiest to use poster paint seems to be a product called Biggie Alphacolor

Brilliants. These are two inch square cakes of poster paint in plastic containers. They are used by adding water to the cake with a brush. The colors are good; there is little preparation needed for their use and very little mess involved at any stage. The cakes seem to really last. They may be obtained individually or in sets of twelve. They require a fraction of the storage space that other forms of poster paint require.

WATER COLOR SETS: Sets of eight colors with semi-moist pans are satisfactory. Check to see if the brush offered as part of the set is good in quality. Water colors are transparent in contrast to the opaque poster paints. The values of the color are made by the mixture of paint with water and by the way the paint is applied. This makes water colors more difficult to control and not very suitable below the fourth grade level.

BRUSHES: A good all purpose easel brush will fill most needs. Rounds with camel hair about one inch long are usually suitable for general work. Brushes should also be tested. When wet, the tip should come to a point.

WATER PANS: These can be purchased or substituted with foil tins, various container covers and numerous items you may find in your surroundings. They are used for paint and water.

MARKERS: Water base markers are good to use for paper work. Permanent markers are good for marking many difficult surfaces and often not suitable for paper work. When used on many kinds of paper, the marks are apt to go through to the working surface. Permanent markers can do extensive damage to clothing, walls and many other surfaces. Markers seem to be a waste if not used and cared for properly. Unlike pencils

and crayons, almost no pressure can be applied to a marker. Pressure damages the tip and causes a loss of control over the flow of the marker. Children are very inclined to press hard. This is a habit they should be encouraged to overcome regardless of the writing or drawing tool they are using. Markers should be kept covered when not in use because they dry out very quickly. These two factors need to be explained to those using markers. Markers can be ruined in one activity if misused. There are a variety of brands and sizes available. It seems best to suggest that you read labels very carefully and test the markers to decide what you need. Markers are apt to dry up if stored for long periods of time even if they have never been used. GLUE and PASTE: Elmer's Glue All or School Glue and similiar products are good all purpose glues that are safe to use and

effective for paper and many other materials. Various white pastes are safe and acceptable for paper work. Rubber or paper cement offers both permanent and temporary bonds for paper. For a permanent bond, both surfaces are covered with the cement and allowed to dry until tacky. The surfaces should then be carefully joined together. Applying the cement to just one surface results in a more temporary bond. Any excess of cement can be rolled off when dry. It seems best not to use these cements with children below the fourth grade level and to supervise use with older children. Rubber and paper cement can usually be obtained in four ounce cans with a brush in the cap. This seems advisable because a brush used in the cement is apt to be ruined. The four ounce cans can be refilled from a larger can. There is a thinner that can be used if the cement thickens.

TAPE: Masking tape can be used on most surfaces and can be removed without causing damage. If pieces of tape are made into rolls with the sticky side out and flattened, they can be placed between objects as needed. The tape will hold without showing. Scotch tape serves many purposes. Care should be taken when applying it to walls. It sometimes removes paint or leaves marks. It is transparent but always seems to show a little. The rolling trick also works with scotch tape.

PROTECTIVE COATINGS: Clear plastic protective sprays usually seal with a waterproof coating. They are easy to apply and dry quickly. Krylon and Blair are two effective products. Hair sprays can also be used. Varnish and shellac are also good. Shellac is not waterproof but varnish is. Both need drying time. You also need brushes and solvent for cleaning the brushes unless you select

varnish and shellac in spray cans. All pressurized spray containers need to be handled with caution and never misused. The fumes are harmful and the contents are very inflammable. It would be wise to read carefully the cautions on the label and act accordingly.

CLAY: Plasticine is an oil base non-hardening clay that can be reused. It comes in various colors and is very easy to work with. If it seems hard, just handle it with your hands until the warmth of your hands softens it. Each person needs at least a quarter of a pound to work with. It is usually prepared in four bar packages that total one pound.

ONE OF A KIND STUFF THAT IS VERY HELPFUL: As you work with art materials, you will build your own list. Starting suggestions would include: paper cutter, pencil sharpner, paper punch, stapler, hammer, brayer and X-acto or utility knife.

He saw what
he created
was good
and he also
rested